DOVETAILED CORNERS

We gratefully acknowledge The Finnish-American Reporter (Superior, Wisconsin)
for featuring a selection of prose poems and photographs in their publication.

ISBN 0-930100-69-7
Second Printing, 2000

Publisher's Address:
Holy Cow! Press
Post Office Box 3170
Mount Royal Station
Duluth, Minnesota 55803

This project was supported, in part, by a grant from The Arrowhead Regional Arts Council,
through an appropriation from the Minnesota State Legislature, and by generous individuals.

DOVETAILED CORNERS

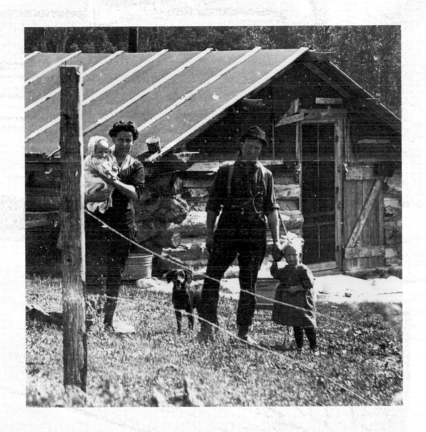

Prose Poems by Jim Johnson

Photographs by Marlene Wisuri and J.C. Hendricks

HOLY COW! PRESS · 1996 · DULUTH, MINNESOTA

Introduction

My GRANDPARENTS AND THEIR FRIENDS were immigrants who kept many of their Finnish traditions alive in America. I grew up wanting to be American and tried to ignore their uniqueness. It was only when I was in my 20s and became interested in my identity that I realized I had been fortunate to have known true pioneers. By this time the log buildings they had built were decaying; the fields they had cleared were being reclaimed by the forests; their farms were abandoned. These pioneers themselves were dying and their stories would be forgotten. As a writer I felt it was my mission to preserve them.

Ethnicity is an important part of my family history as it is for many other Americans. As it was important for me to find out about my Finnishness, it is important for others to find out about their own ethnicity. And for those who have difficulty in finding their ethnicity, their family histories are, nevertheless, important. Through the learning of our family history we come to find out about ourselves. And as we learn about ourselves, we come to respect that process and how others need to learn about themselves as well. It is not so much that I am a Finnish-American as it is that I am part of a history just as you are part of a history and both of us understand the importance of finding out who each one of us is through our own family history.

Often, however, our clues to the past are scant. The stories that we have are incomplete. The storyteller didn't know, had forgotten, or didn't want to admit to some of the facts. No one now remembers who the people in the old photographs were. So we fill in what we don't know the best we can. Historians may object to

the use of imagination in any history. Yet haven't historians themselves liberally used their imaginations as well? We know the truth is more than the sum of the facts. And isn't it interesting that so many of the family histories that we do know do not fit the official version of history that we have been told?

Most of the buildings in the photographs by Marlene Wisuri and her grandfather, J.C. Hendricks, are made of logs. As carefully hewn as these logs were, there were spaces between the logs that needed to be chinked to keep the cold winds out, just as there are spaces between our words, our lines, our stories, our histories, our truths that need to be somehow filled in. There is so much we don't know. Perhaps that is why fiction is so important. While the photographs are real and many of the names I have chosen are also real, the stories are fiction.

I have chosen to present these stories as prose poems. Visually they are rectangular like the photographs, like the houses, usually two rooms down and two rooms up. Also, the prose poem seems to me to be a collaboration itself. Prose, being simple yet functional, seems to fit the lives of these people whose beauty and suffering is at the same time poetic. There is a narrative to their lives that these people want to tell.

Dovetailed Corners is then a fictional collaboration of many things.

Jim Johnson

Introduction

PHOTOGRAPHS OFFER A TANTALIZING APPROXIMATION of reality as the subjects etch themselves with light on silvered surfaces in frozen moments of time. But the reality of photographs is devoid of sound or smell, the feel of hot sun or of icy cold. They lack dimension and often color as well. We are left with silent, unblinking reminders of what once was. They have what I like to think of as "poetic possibility" to arouse in us our own memories. They prompt us to fill in the blanks left by the omission of so many important elements of lived lives. What remain in photographs are wonderfully etched details that can provide a wealth of information and possibilities for speculation to which we can bring experience, amazement, recollection, and emotion. Therein, I believe, lies the magic and power of photography.

My maternal grandparents, Jesse C. and May Gibson Hendricks left family behind in Iowa and moved to Balsam Township, Itasca County, northern Minnesota in 1909. There, in Jesse's words they "carved a farm out of the wilderness." J.C., as he was always known, began to make photographs in about 1912 with a view camera outfit purchased from the Sears Roebuck catalog. For the next several years, one of his recreational activities—and they were few in that hard-working life—was to travel throughout the township and photograph his neighbors, many of whom were Finnish immigrants. He also photographed the extended family and their typical activities, most notably the hunting. The glass plate negatives were developed in a pantry darkroom by my grandmother May. She printed the

plates by holding the contact printing frame against her stomach, then exposed the photographic paper to sunlight, and pressed it once again against her body. The resulting prints were mounted on cardboard and often proudly displayed at Bovey Farmers' Day or the Itasca County Fair. All of my grandfather's prints in this book were printed from the original glass plate negatives and are bordered in black.

I first began documenting the remnants of the Finnish immigrant life that is my paternal heritage about twenty years ago and have since taken photographs in northern Minnesota and Wisconsin and Michigan's Upper Peninsula—all areas of heavy Finnish settlement. Using black and white film in 35 mm and 2¼ inch format cameras, I sought to capture these elegiac remains in a straightforward documentary style. Many of the buildings and artifacts had already been abandoned and begun slipping into decay. A few, like the Wirtanen Farm in St. Louis County, Minnesota, and the Hanka Homestead in the Upper Peninsula of Michigan, have been restored by preservationists. They offer a glimpse into what pioneer immigrant life might have been and some of my photographs were made there. Perhaps we should not grieve too much at the passing of the remainder. Nostalgia is an empty emotion that avoids harsh realities and romanticizes the past. These graying, wooden relics age and die gracefully; first lying down for a time and eventually returning to the earth to nourish new growth. Change is inevitable, but the photographs remain to feed our imaginations and inspire our poetry.

Marlene Wisuri

Dovetailed Corners : the Collaboration

PURISTS IN BOTH THE VISUAL AND LITERARY ARTS are often of the opinion that "the image must stand on its own" or "trying to illustrate limits the readers imagination." Obviously we believe that words and images can serve to reinforce and enhance each other, but this coming together must have an underlying commonalty and a certain shared spirit in order to successfully meld and speak to the reader/viewer.

Appropriately, our collaboration began over a cup of coffee in 1986 following the publication of Jim's first book, *Finns in Minnesota Midwinter.* Marlene realized that the photographs she was doing and that her grandfather, J. C. Hendricks, had done in the 1910s and 20s were the visual equivalent of Jim's poetry. We have since explored, discussed, discarded, and recombined words and images until finally the work has come together with a resonance that reflects our mutual agreement with regard to form and subject matter.

We have sought to weave a narrative thread through the poems and photographs that tells the story of a fictional immigrant family: the first generation who came to and homesteaded in Northern Minnesota and the second and third generations who left the land and later returned looking for pieces of their past. There is the tension between the past and the present in the poems as there is between the earlier and more recent photographs. The poems, together with the photographs, suggest a fragmentary record of a larger story. We have not attempted to present an accurate historical document, rather an unsentimental, but artistic interpretation of specific and universal experiences filtered through the eyes, minds, and hearts of a poet and two photographers.

<div align="right">

Jim Johnson Marlene Wisuri

January, 1996

</div>

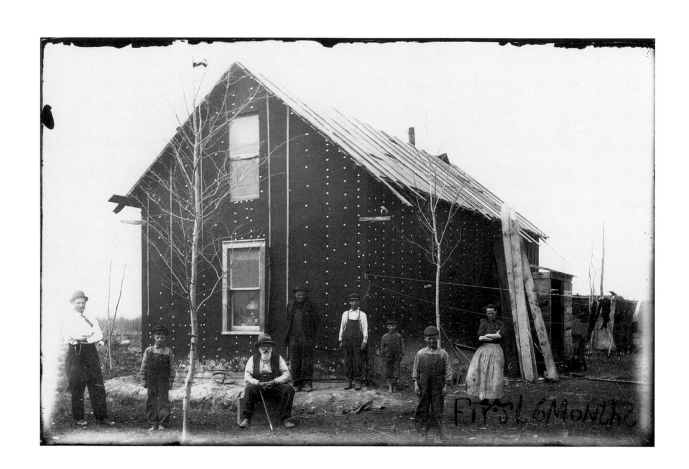

Sulo's mother had written from a place called Balsam Township. She wanted her children. This is what mothers do. If they go away, they want their children. They are like the trees after the fall branching out, wanting their leaves to come, come back again. So they came. This is what the children do. They are like the leaves that go into the ground and join the roots which are so much like the branches of the trees. All except Uno who was too stubborn. Sulo, Martha, Little Aune, Aune Täti, and Lillian, who was sick, they all came.

The trip was long. And Aune Täti was the first to see the new world. She saw a woman not made of stone but waving, waving to them from out of the fog.

Hurry up now, the woman said, *I put on the coffee just for you.*

That god is really an old dog who sleeps by the woodstove, in the sunlight, or after you go to work, on your bed, an old dog who sleeps all day and eats grass, the same old dog in this country as the old dog in the old country, the old dog who follows you into the kitchen and back, out to the outhouse, or to the barn, or across an ocean. They traveled across an ocean and, as if that weren't enough, all the way from New York to Duluth by train just to find out. Somewhere along the way Lillian died. Aune Täti said it was in Indiana but Sulo said it was in Ohio. That was all either of them would say about it. From the train it probably looked the same.

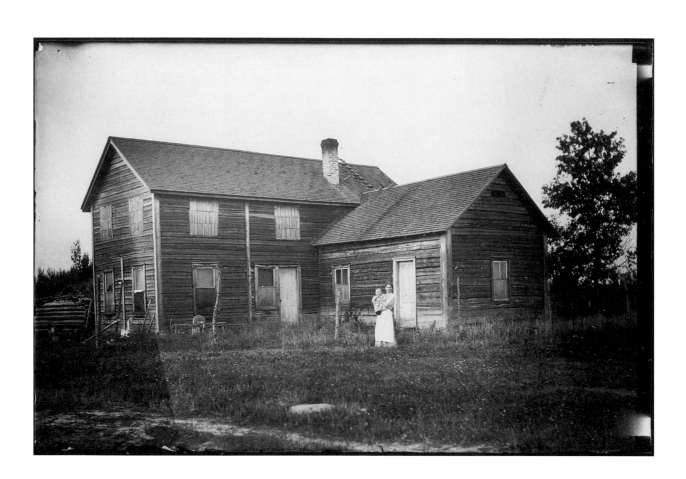

In this clearcut world, a woman, how she looks so much like you, holds a child, it might be our child, a child dressed in a long white dress, its arms so short it looks like a cross. Now in a churchyard where the wind's gray gossip turns into stone someone has left those plastic pink roses, planted them in the soil that, in the spring, caved in like your eyes.

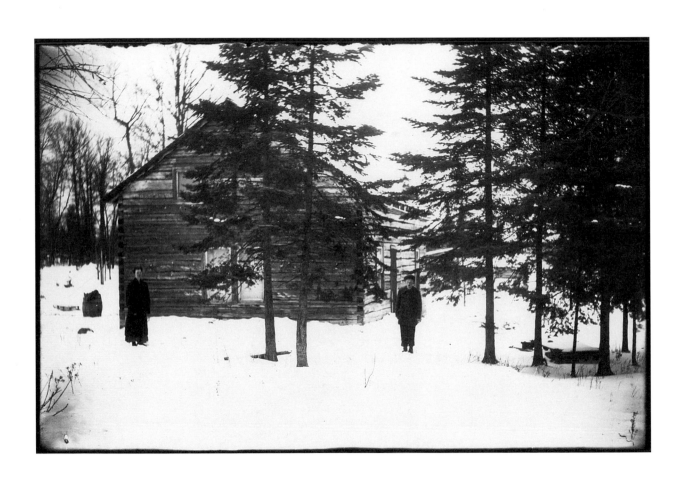

All these houses are, the logs straight. Hewn with an ax they have perfect corners. Even the trees left standing stand up straight. It doesn't matter. A boy comes into the house his face scrubbed by the cold. He puts his finger into the dough. It doesn't matter. His mother braids her bread as if it were a daughter's long blond hair in which case it would be like her own. It doesn't matter. The father dropped the tractor they couldn't afford through the ice on Kangas Lake. It doesn't matter. Soon deer will browse among the Cats, John Deeres, pulp trucks, and Chevys as if they too came from out of an old country and into a new.

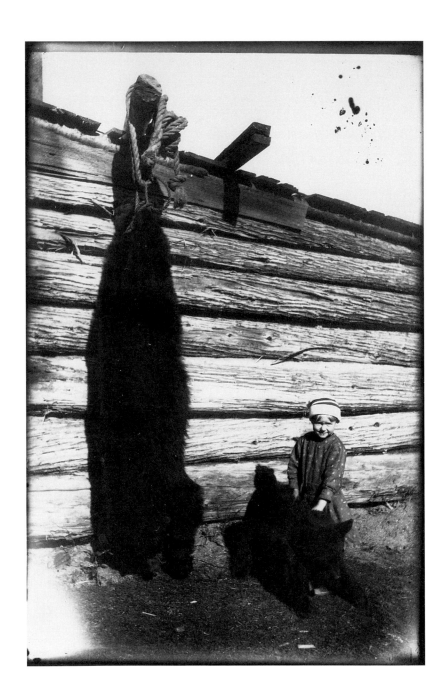

The bear is the longest night of the year, without stars or moon or soul. Sulo's mother Aija Liisa had married a man named John Ranta. John Ranta was a large man who wore a bear coat and traveled to the lumber camps with his pockets stuffed with money. In the old country there was a story about a bear that had been killed. When it was skinned out, a money belt was found around its waist. There was no doubt it was a man in the form of a bear. There was no doubt this was John Ranta. One night on his way to lumber camp he was shot. Whether someone thought him to be a bear or just the man with the payroll in his coat, no one could be sure. But Aija Liisa cried, cried until his shadow came. When it came, it came at night, right up the steps to the porch where it stopped to knock, knock the can of garbage off.

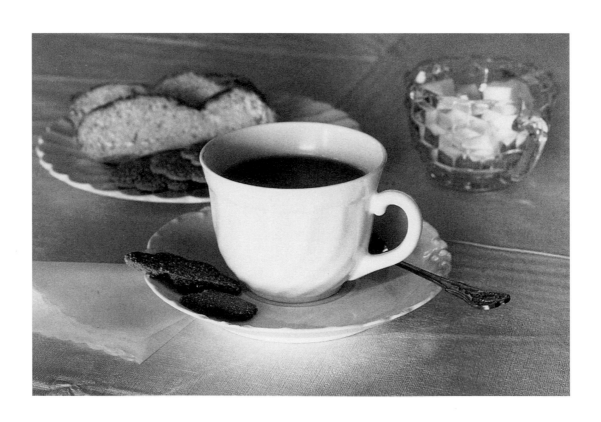

It didn't matter that it was three o'clock. Every day when the men came home from the mines the table was set. Full table cloth. Coffee cups and saucers. Plates and silverware. Fresh baked bread and butter. Head cheese and cake pieces. And, of course, fresh coffee. While the men drank coffee and ate, they watched the direction of the wind and talked about whether the hay was dry enough or if they should go fishing instead. If Sulo said it was dry enough, Matt Braa said it wasn't, and Sulo said,

You have to believe. And Matt Braa said,

Yes, it is important to believe in something, but if you believe in something, you have to believe all the way and with all these mosquitos I just can't believe all the way.

Then the men went fishing. And the women knew supper would be late.

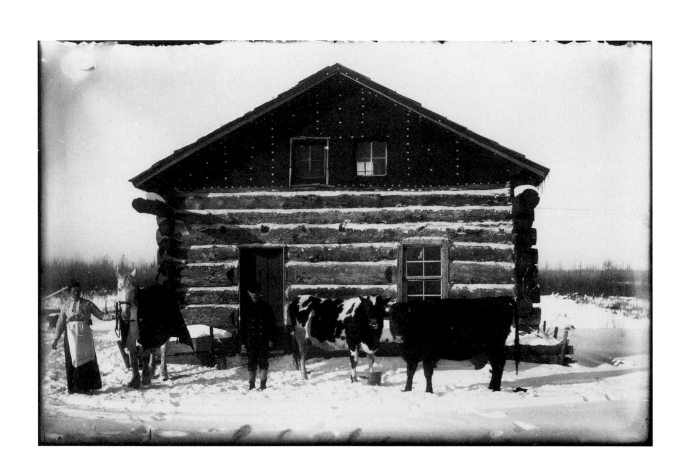

There was a time when the women stood with the cows because they were for milking and the men stood with the horses because they were for plowing or for pulling logs out of the swamp. The women even went out to the cow barn and the men went out to the horse barn. Yet each body, each body in this universe is attracted to each other body, as Martha the woman and Sulo the man, with a force stronger the more massive each body is and the closer each body is to the other body. That there were gaps between the logs where the wind blew through may have been another factor. This is the same force that caused objects to fall; an apple, for example, because it was so red.

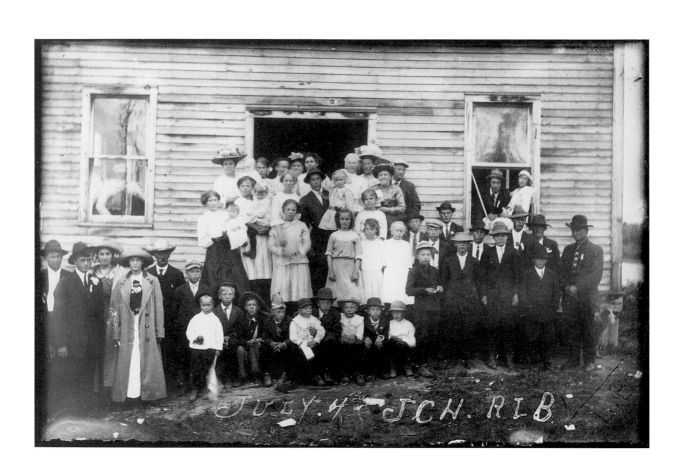

On Saturday nights they had dances at the Finn Hall but you had to listen to the communist speaker before you could dance. Sometimes Viola Turpeinen came and played the accordion that looked so much like these log houses you just knew music lived inside. I suppose that is why all the girls loved her so much. The same music lived inside each of them like the wild strawberries along the roads, the daisies in the fields, or the stars in their eyes at night. But it was not only the music that she played; it was her long blond hair always in ringlets even in the later years of her life. And her voice was like a morning without cows. She traveled from town to town; she had even lived in New York City. Whenever she came to the Finn Hall, Little Aune said, they always arrived early just to see her. Of course, everywhere they went they went early. She supposed they would even be early to eternity.

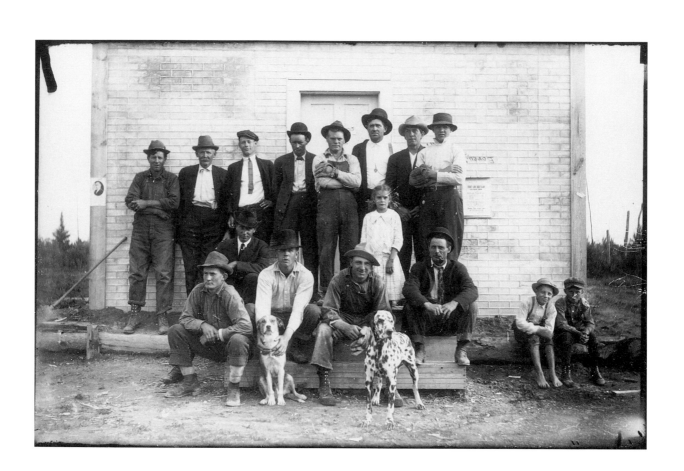

When the dancing started, the men went outside to look at the sky. It was then when they began to connect the stars and what the speaker had to say that everyone should receive equal pay.

To be buried all day and rise up only at night, what kind of a life is that? Sulo asked as he took a swallow of the moon and passed the bottle down.

Some of the men never rose again.

What does it matter? another asked and passed the bottle to Matt Braa who took a sip and added,

This is America.

And what kind of a life is that, Sulo thought, *to leave your own homeland and sail across an ocean only to learn another language in which your own last name is a piece of women's underwear?*

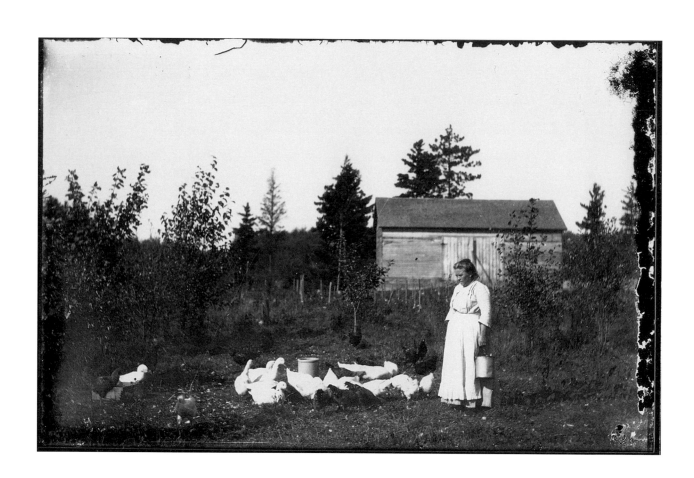

Oh to live in this world, to live in this world that is one communist animal, the Co-op label on all your cans, maybe even the coffee can with the small hammer and sickle. We know the leaves are not separated from the branches, the branches not separated from the trees, the trees not separated from their roots, their roots not separated from the earth. Oh to live in this world.

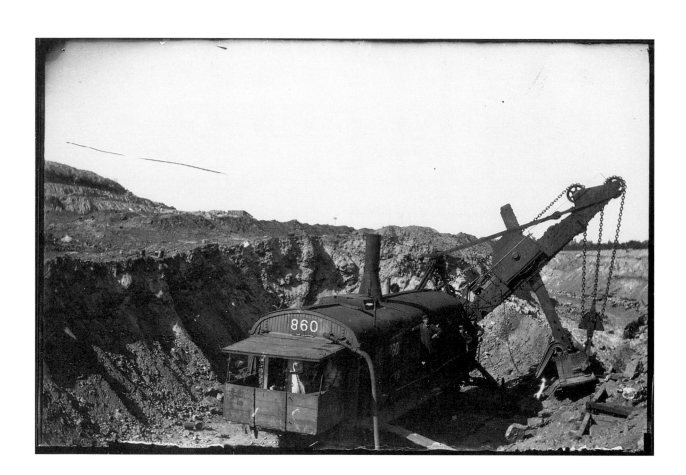

They took the iron ore from the ground, dumped the ground, the strata in reverse order, ever so carefully charted so that the dump was a reflection of the pit, just like the trees at the edge of the lake and the reflections of those trees, the present growing out into both the past and the future. Like when Sulo walked into the house and left those red tracks across the floor, Martha could stand it no longer.

Look at what you did, she said, and all the dogs under the table looked up at her.

The hills are red, Sulo said looking at the tracks. *So when it rains the streets turn red.*

And Martha said trying to hold the rain back once again, *These streets are not made of gold after all.*

If they were, then we would have enough money to go back to the old country, Sulo said.

And she said, *If they were we wouldn't need to.*

Then the rain fell shrieking down, the earth red.

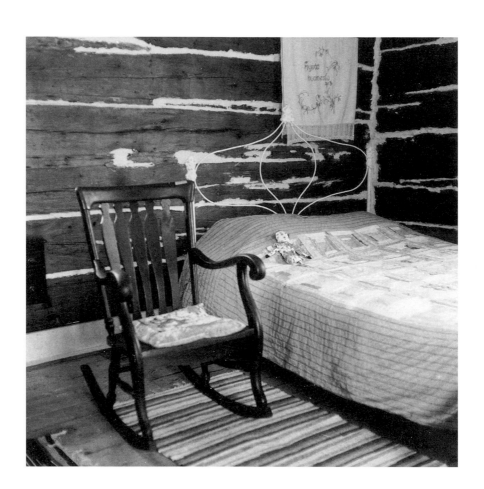

There was a strip of color between this world and the next. Sulo saw it in the east in the morning when he went to work and they lowered him in the cage into the earth. He saw it in the west when he rose again from the dead. Martha saw it too. Even when she was so old she had forgotten so long into her past she could only remember what was the beginning was the earth curving slowly into gray, except for that thin streak between what was and what will be. That she wove into her rugs.

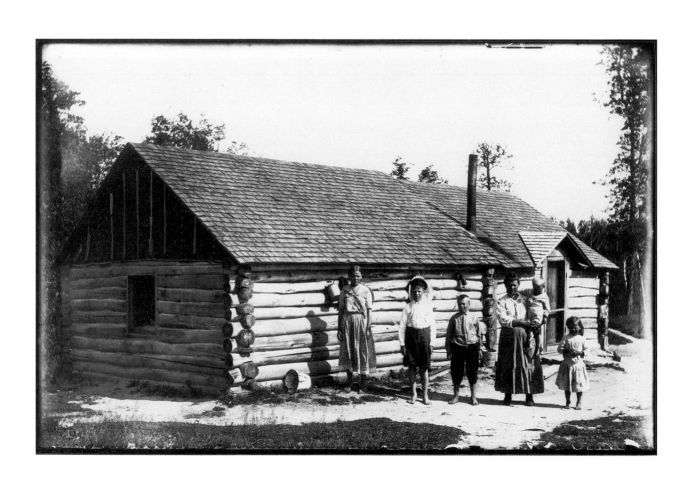

And the way some of these people had to live. Not much money. Didn't even know how to put in a garden. Not much of a house, a trapper's shack really. The logs not even chinked with the price of furs. A woman and all her kids so thin, together they barely cast a single shadow. It was said once a family ate the world's record northern pike in one sitting. Imagine the man returned and found only the bones. Of course, he never did.

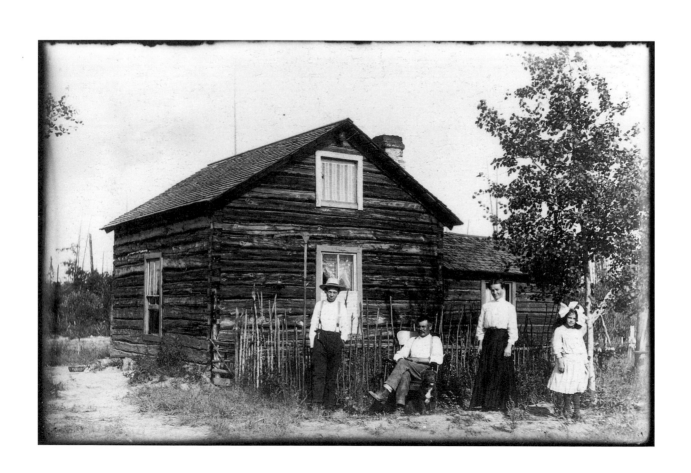

Now in Northeastern Minnesota the mines shut down. Around here it is said the unemployed outnumber even the mosquitos. They leave their eggs in snowmelt marshes, water-filled tree hollows, hoofprints, or the tracks of logging trucks. Their eggs lying dormant, overwinter, then when thawed come to life. The pupa breathing through trumpets splits out of its skin into a winged adult. The female is attracted by warm moist blood, needing blood for eggs. Needing blood for eggs.

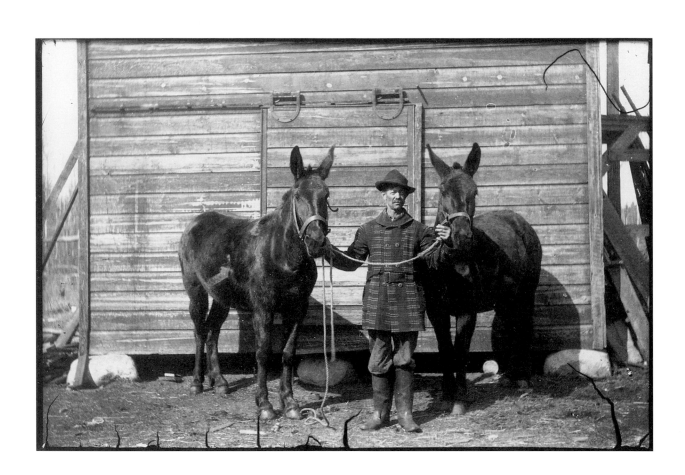

When Sulo said, *I am not going to live like this*, Martha asked,

Then what will you do? even though she knew. That a man is

married we know by the way he has grown to look like her over the

years. The older he gets the more we know this to be true. He is like

the wind and she is like the land. The older they get the more they

look like each other. His mind had already made up its mind.

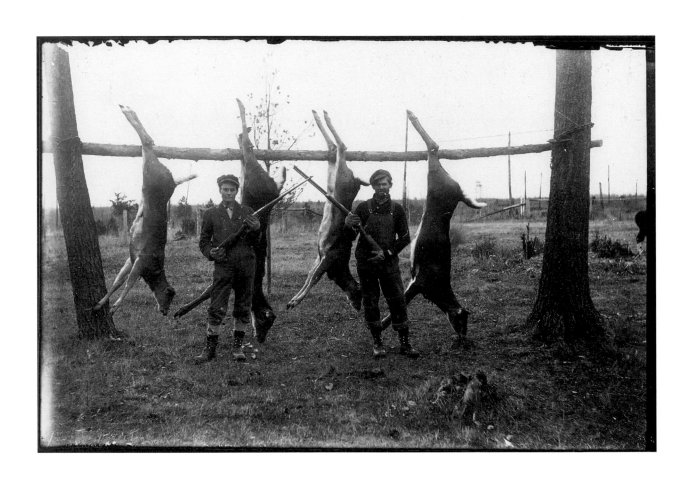

That was the year when in the fall the men went hunting. It was even written, penciled in on the wall of the deer shack that year the year: *1913: two does, one fawn, and a cat.*

Martha was always the one who didn't know. She told him everything; he told her nothing. There were gaps, like the cracks between the logs where the wind blew through. She wanted to know and what she didn't know she filled in. That's what happens when a person doesn't talk. We chink in to keep the cold winds out. Sometimes she would try not to speak. *If I went long enough without talking maybe,* she thought, *he would want to know and would ask.* She could only stay mad for hours while he could stay mad for days. That's how they were. After a while she would always tell him exactly what she was thinking so he never had to ask. Maybe he never would. She just couldn't wait that long. That's how she was.

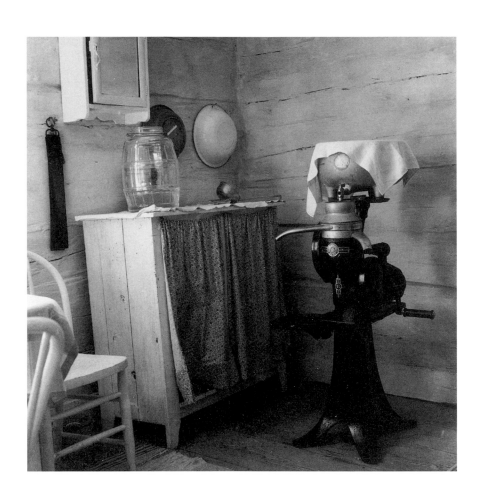

Because last night he shot a deer, shot a deer with a twenty-two caliber rifle, one shot between the eyes, tonight he stopped off at the Big Noise Tavern. At the end of the dimly lit bar he sits. His own eyes quick like a deer that stood that summer in the river. Its head, its ears jerked up. Already the bugs were bad. The eyes stunned by the light, last night just beyond the yardlight, too dark to be the neighbor's cow. Now all is provided for. In jar after cellar jar seeing is once again suspended in a yellow brine.

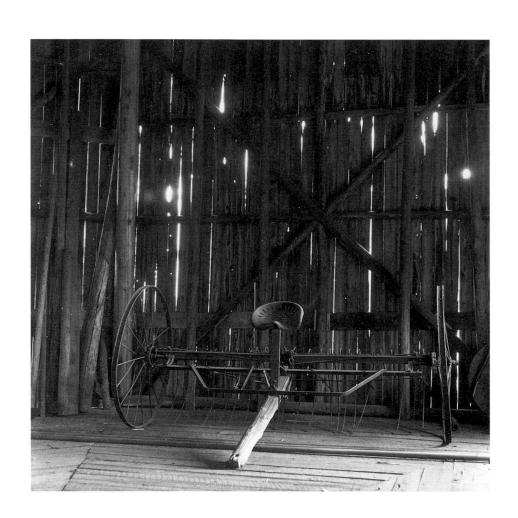

When he said he stopped off at the old Rouho place and that there was a tractor, a John Deere, parked right there in the front yard with a *For Sale* sign leaning against the steering wheel, she asked, *how many eggs?*

When he said it was a '47 and in such good condition that it even had the original paint, she asked, *how do you want them?* and cracked two eggs against the edge of the iron skillet and watched them like the first snow in November blowing across the edge of the field where the yolks had broken.

When he said they were such a nice couple he was glad he had had the time to finally stop and talk, she asked, *more coffee?*

When he said they bought it from Old Man Rouho when they bought the place, she asked, *you want any toast?*

As she poured the hot coffee arcing down into his cup, he asked, *where was it that they came from?* and she slid the two eggs onto his plate with wooden spatula and asked, *anything else?*

And when he said, *I always have two eggs,*

she said, *from over by Sebeka.*

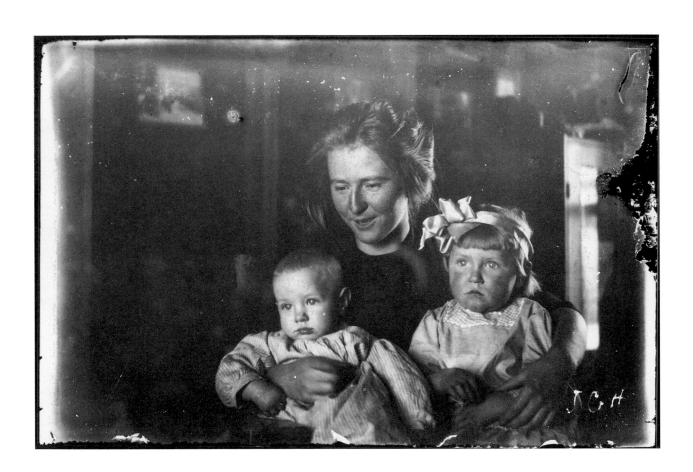

The winter came early. Maybe Martha started to pick at Sulo, the way he slurped his coffee. *It's because of my moustache*, Sulo said and stopped slurping. Martha noticed the distant birches. No matter how much had been clearcut it seemed they were always returning. He thought it was because there were no more kids, only the two: Little Aune and Bobby. Whatever they once had, it seemed to him, they let it go. It didn't matter who was the first, they both let it happen. He knew one day one of them would die. Maybe they would be old. The one who lived would attend the funeral and think about their love and how they could have lived their lives together all those years and yet have been happy, but instead, they let it go. The one who lived would have waited for death that much sadder. Of course, the one who lived would eventually die. Then and only then, none of this would have mattered.

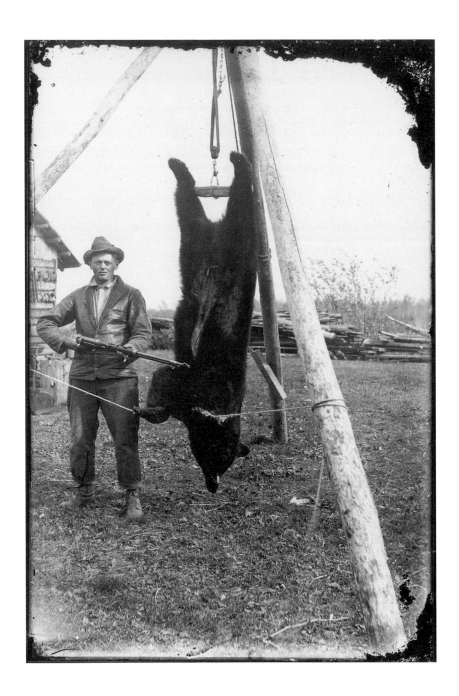

When the men came back from the woods, they had one bear and one deer. It was a nice four-point buck, but they didn't want to talk about it. You could tell they had had too much to drink. Their eyes were funny that way. So you knew you better not ask. It seems Sulo's cousin had come up from Minneapolis and he was supposed to have been the driver driving the deer out to Sulo and Matt Braa and the others, but instead of running the deer toward them, the deer stopped and Sulo's cousin then shot and the deer fell over. No other deer came out. So the men said to Sulo's cousin that since he already shot his deer he would have to drive again and this time Sulo's cousin saw three deer, but since he already had his deer, didn't shoot. The men didn't see these deer come out, and when Sulo's cousin from Minneapolis asked about the three deer, the men said maybe he should go back to the shack since he had already shot his deer. On the way back to the shack Sulo's cousin thought he saw a mound of dirt and leaves begin to move so he went for a closer look. It was a bear and he shot it. Just like that. So when the men came from the woods, they had one deer and one bear. If one of the men would have asked Sulo's cousin about it, he would have said it was all dumb luck. But no one did. So when the bear suddenly rose onto its hind legs one more time, in the backyard, he shot it again. Just like that.

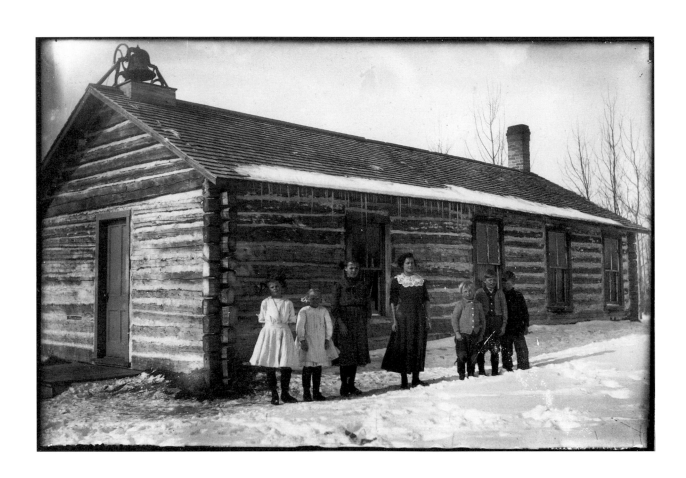

Although the house was built of horizontal logs well-chinked, icicles hung from the roof. On a warm day, she could watch the water drip slowly down and down until the heavy drop of water at the very tip needed time to consider. It was like the stemmed crystal from which she sipped as the great men and women all around her began to dance to the music and one man in a fine black suit with long tails asked her, *Little Aune is it?* to dance with him, but she, being so very young, needed time to consider. Now in the evening the trees at the edge of the field, what is there to do but continue on?

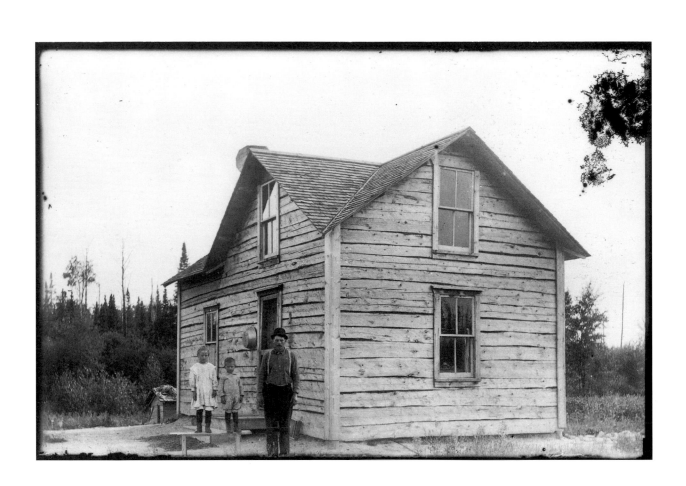

Be yourself, Martha always said. What self is that, the one that night that turned, turned four-legged and ran, ran, its own inward parts howling out, out to the end of the long chain of sound? Oh now there is this bounty on your soul which requires four paws of evidence. Yet two moons balance where there would be eyes. Even lichen grows on the southside pines. The popple trees are without leaves for the second time this year. Then when they become the sign of the cross, you will become yourself again and forget.

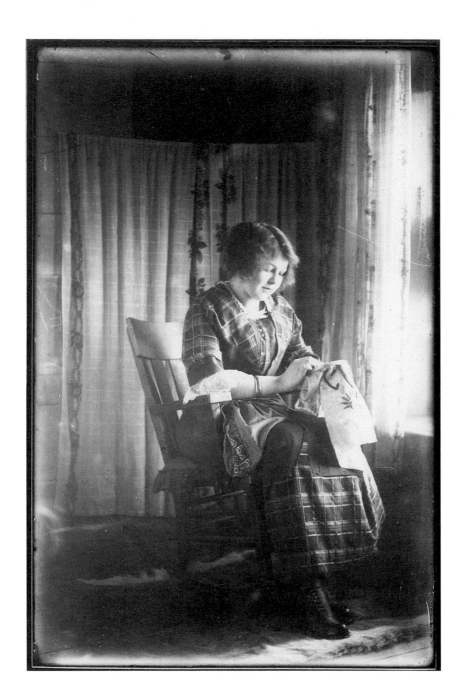

She was the first to see, though she never told anyone, how his teeth were then pointed and there was hair on his hands, his feet, and between his legs something that curled up like a scythe, and oh for so many years then the crops were bad and she knew then each one of us is of two worlds. Now you can see how the grass has been cut, cut with a scythe sharp as the new moon.

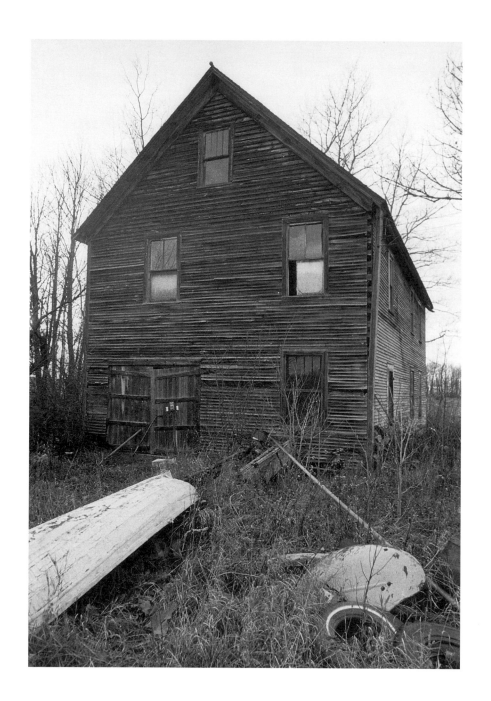

If I had the time, Sulo used to say, I might just sit out on a rusted tractor seat, its base set in a slab of concrete, and look, look out over these fields until the twilight comes out of the trees, in among the young popples like weeds, and then rises up toward the house. Luckily, I built the house on higher ground. There would be nothing else to do then but push out the old rowboat and row out over those weeds and cast. Cast out and reel in. Cast out and reel in. Cast out and reel in. Just maybe I might hook into something. If I had the time, I might do anything.

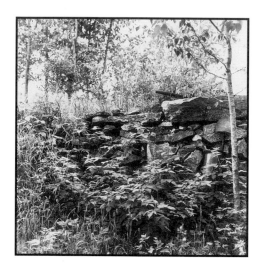

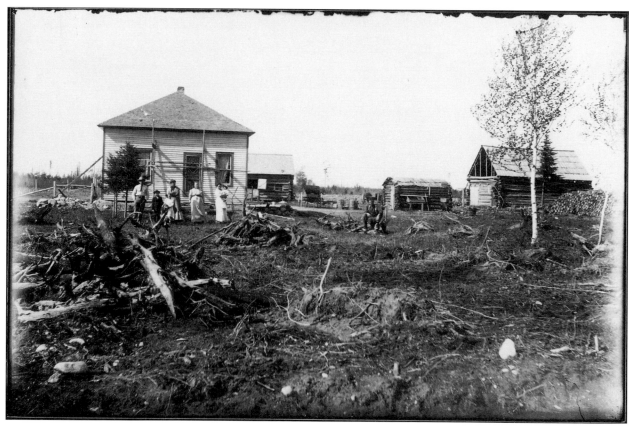

To look at the night sky with all the stars above is to look at those muddy fields where each year we carried rocks, piled them in piles beyond the fields. What I know is, those rocks were like souls. They defied gravity. Each year more and more rocks rose up to turn a plow onto itself, or break a mower's teeth, or a man's back. Maybe if we would have left them in the fields, then they would have risen into the sky and become the stars. Instead in those muddy fields we wore birchbark shoes, saved our good shoes, believing, if we carried enough rocks, the sun might shine on Sunday.

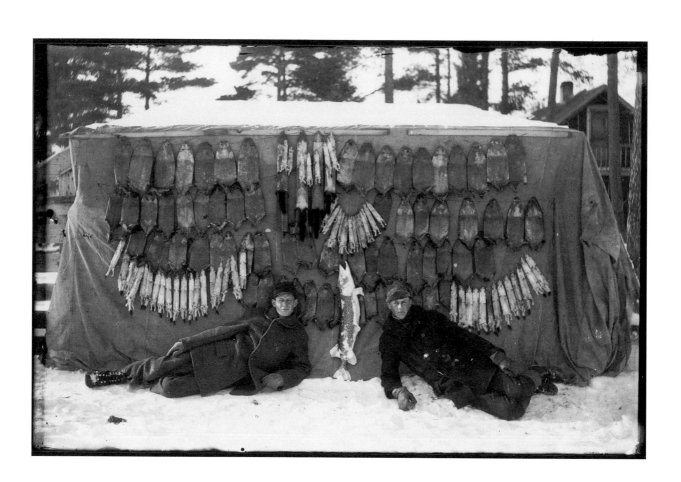

With a knife honed to an edge cut in at the ankles and begin to peel the skin back from the hind legs and up, half-cut at the tail, and over the back and up the front legs and over again, being careful at the eyes, the eyes should stay in—the body gray, slick as an ancient map of the world, the middle of some continents marked *unknown*. The blue veins are the same, Aune Täti who married Polish would know. Winter nights are long this far north. Even the dark branches of the fir trees grow legs and tails. And, of course, there is blood.

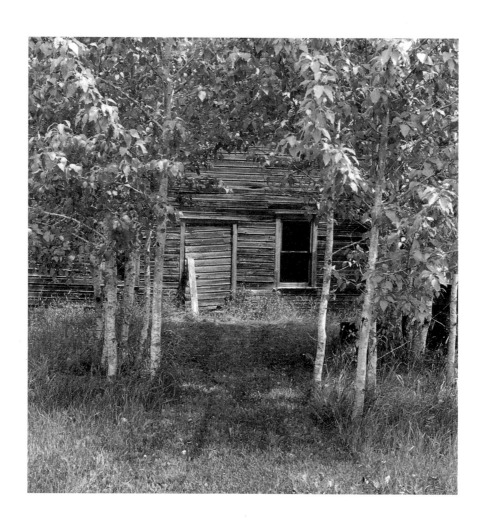

Now if you look long enough at the grain of wood, the barn does not get built. Just as well. You can see how the roof collapsed. Where the grain gives way to a knot, a hand reaches for the sun. They found her, not so little anymore, out on the ice frozen to death. All summer eating black dirt and pregnant. Now the windows of the barn are boarded up. The weight of one winter's afternoon enough to crush all hope. Only the cracks between the logs were filled with oakum white enough to be the sun.

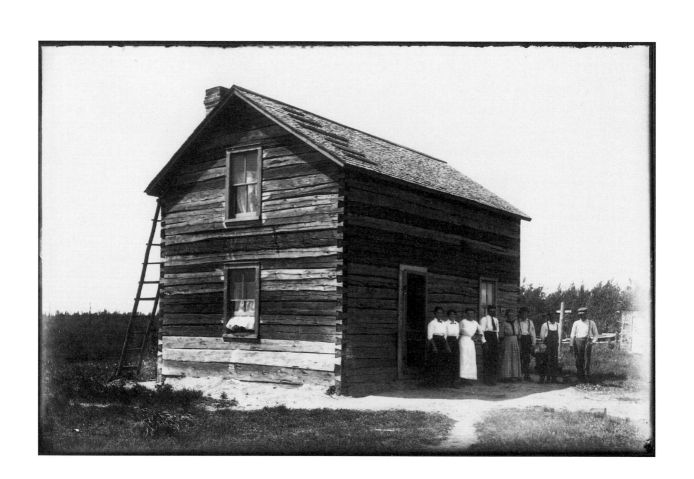

There was the wind in the tops of what trees there were. Inside we could only see the wind, how it moved through the needled branches. How little evidence was ever needed. What was it that we knew for sure, that someone stole our curtains, grabbed them from the outside when no one was looking? After we sided the house and painted it white, you wouldn't have even recognized it if it weren't for the wind. Years later when the house was sold, someone else tore the siding off, so glad to have found the brown log. The little that they knew they knew from fragments found chinked between the logs.

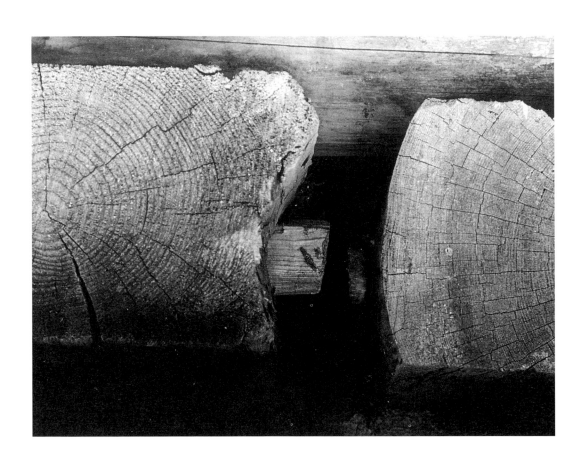

In the evening even the trees stepped out into the fields. It was then when Sulo touched Martha with his hand on her hand, his cheek on her cheek. She had always wanted a man tall as he was honest, with perfect corners. It was then when Sulo, his face unshaven, told Martha,

A woman can trust a man who works with wood. Like the horizon, the logs are squared top and bottom. The right and left edges are like your thigh and mine: one curves in, the other out. They have like us been mortised and tendoned, that they will fit together a lifetime or more, and many white-haired children.

And this time she didn't seem to mind.

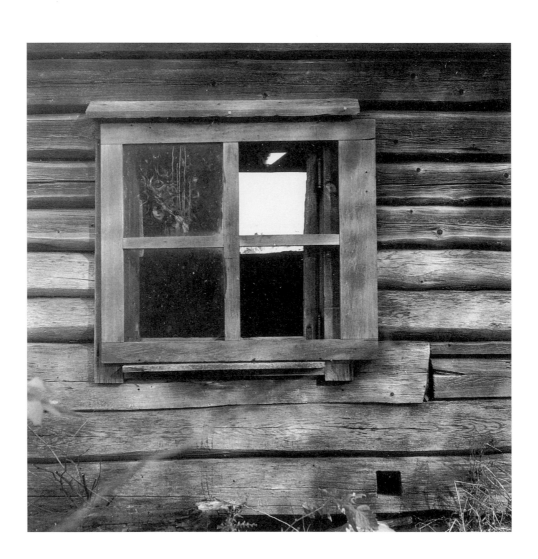

Yet he came to know. Some of these logs aren't straight. But if the one below bent down, so did the one above. Maybe he cut them that way. Or maybe they shifted after the logs went up, the way in a married couple each learns to make do with the other. It takes years of living together. Not true you say. Then look at these logs. The log below the upper window looks like it is split. But it holds together. Some of the logs are even darker that the others.

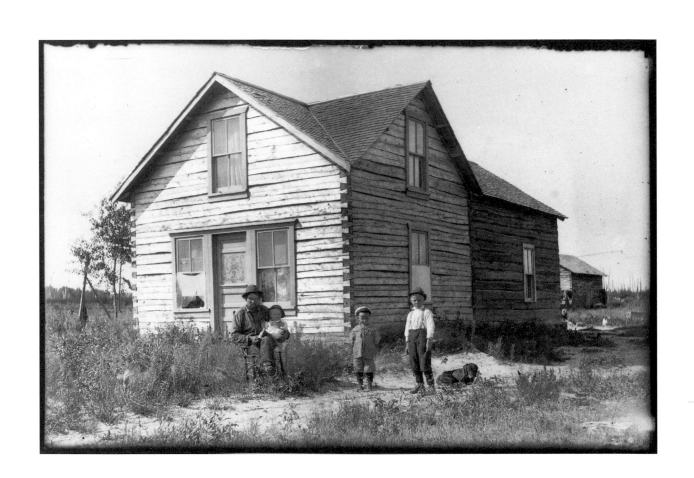

Isn't it enough that these houses stand yet, the logs straight, the corners dovetailed and perfect? In the clearcut at the edge of a swamp where a man took his favorite chair, his throne, and planted it there where the weeds were the thickest, there he sits and watches, as if he rules over all of this. Behind the house it is all lowland, all mosquitos, and all his. Of course, only a woman would tell a man what he doesn't want to hear. When Sulo became hard of hearing, Martha sent him to see a doctor who told her he was only deaf to women's voices. And why was that so hard for her to hear?

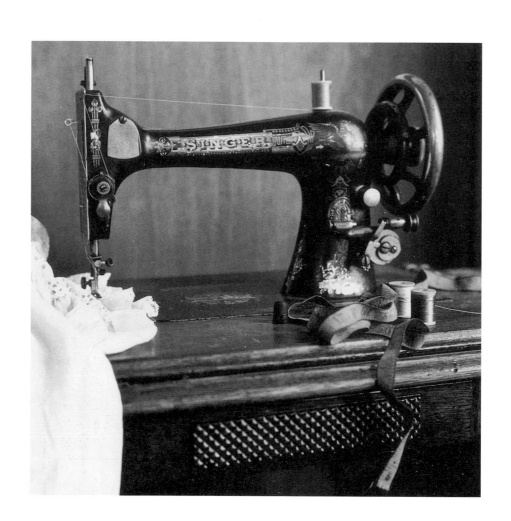

Sulo ran his hand through his hair and there goddamn it! was a wood tick. He pulled out, along with a piece of his skin, what was round and smooth and brown as a seed with tan zigzags down the back, as if they lived only for speed. Then he struck a match. Oh how they flatten like the sun. The family down the road had a Singer sewing machine, the kind with a treadle. If you slid one under and pushed the treadle down, the needled pierced, picked up, and stacked another wood tick. Like an assembly line. You worked all day just to make not enough. So what good are wood ticks? Yet Sulo wavered. He knew the floorboards moaned in his own house. That wildflowers showed in his hayfield. Crickets tuned up the dusk.

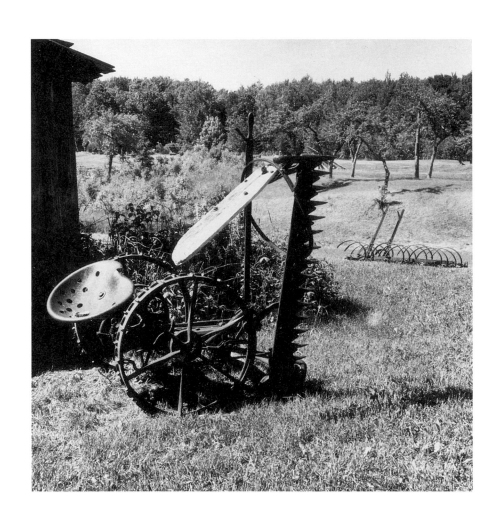

Somewhere the summer heat rises up from a stretch of interstate beside a field of hay. The field is large, used to be larger but down at the bottom beavers dammed the creek. At the near edge is a mower, its arm folded up as if caught in the middle of a rusted salute, still waiting after all these years for orders that never come. Not many flowers in the field yet. To long to look out over a field of wildflowers is to not know farming. Yet the orders never come. Only the wind moves through the grass as easily as you look back into the past.

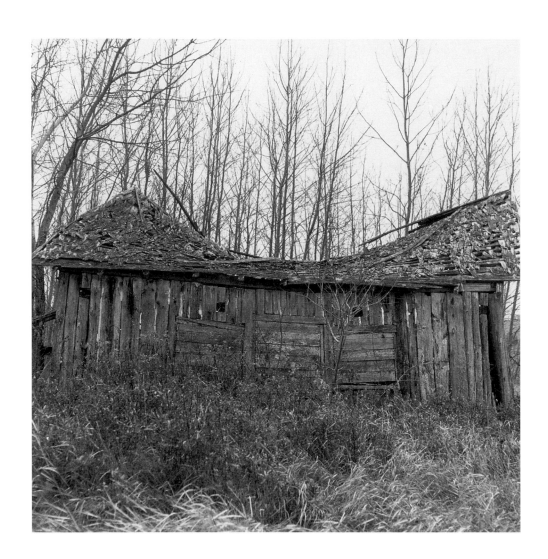

The barn roof collapsed in the middle. Tired of standing alone in the field against the odds-on popple trees, it just sat down. The logs of the one wall need time to consider. Soon they will be what they once were. Like you. In the middle of your life you came back to where you came from. Stopped the car, got out, and walked through the balsam trees. There were but two ruts where the grasses high-centered. Eventually you came to a field. In the middle of the field, so far back in the woods, so smack dab in the middle of this great continent that you might as well say in the middle of this world, now there you are. The barn roof collapsed in the middle.

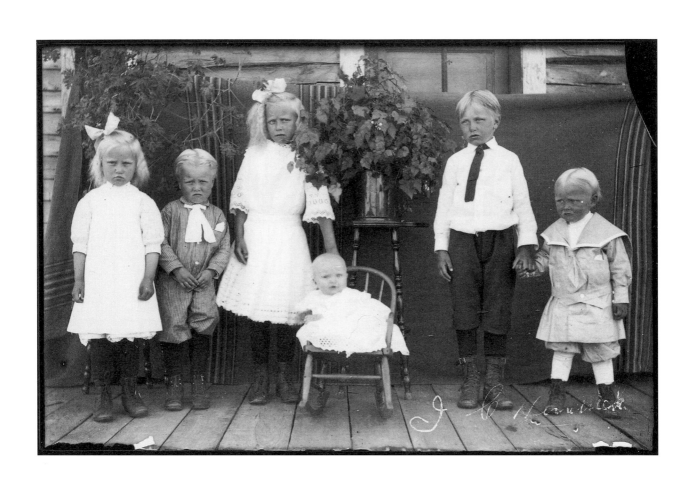

It didn't matter that Bobby didn't want anymore of that *kala mojakka.* His hair so white everyone knew he came from where it snows. They knew too the hardwood stumps that sent out shoots from strong ancestral roots. Now if you're not careful you might even find these shoots growing out from the handle of your own ax. When they went to school, the teacher told them since they would get only five exclamation points in their entire lives, they better save them for something very important and Bobby said all the Finnish kids were so happy—they didn't think they would ever get any!

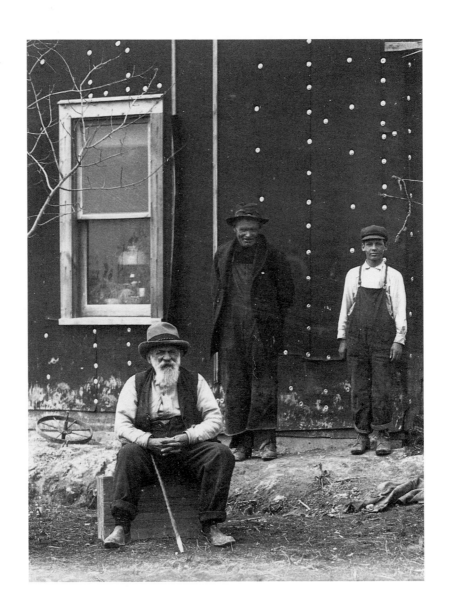

So now you know. Wherever you go, there they are. You don't like to think so. You tell yourself, here they do not exist. There must be quotas, laws. There is always so much anxiety. These immigrants, like so much imagination, will always come to work when you aren't trying. They will show when there is a certain light in the hay barn. One after another they will come. Threadbare, coarse-clothed, dark-bearded, and singing, they will come to show themselves when you are most yourself. In that moment between waking and sleeping when you are most yourself, there they are. Where they came from, you don't know. Only that, here they now are. How dare they be idle.

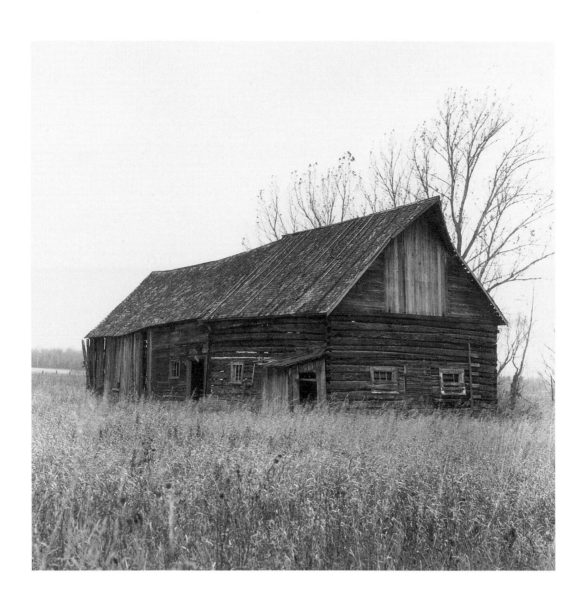

Loneliness itself could crush a barn, a barn that had begun to lean. The ladder stopped before it reached the boarded-up loft, no use going on. Even the trees did not grow straight anymore. Yet, today, I saw out on a limb, a nest, not only of the usual mud, last year's leaves, and twigs, but built upon a sheet of plastic laid down like ground.

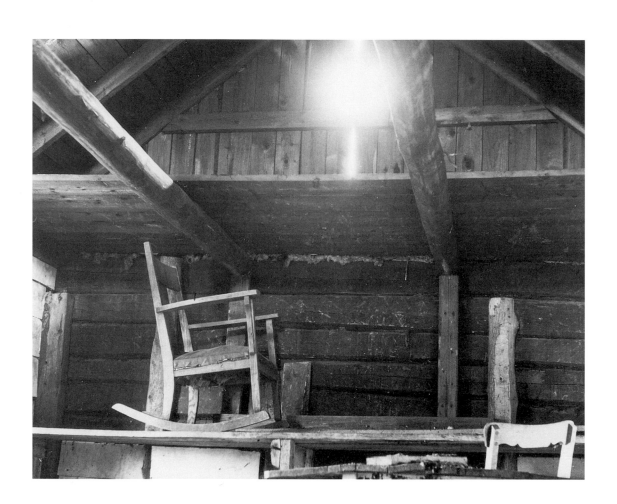

No one ever sat in *isoäiti's* chair. Even after she died, no one ever sat in it. Finally Bobby took it and put it out in the barn. Sometimes now I see her. She is sitting in her chair knitting; she was always knitting. I ask her now and she tells me she knows where she is going. She is already there where each world unravels a single thread. So we must all pull together. The thread you pull unravels; the thread I pull unravels; each unravels until the very end we cannot imagine. For all we know, heaven is a high shelf out in the barn.

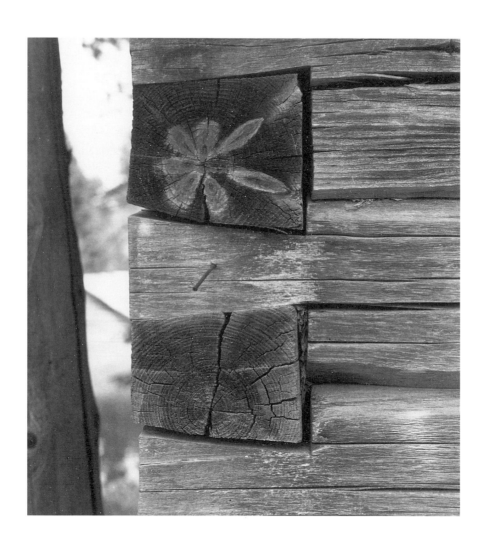

These logs have been cut and dried, squared and notched by a man with an ax. These logs are older than he is and now he is only a memory. In the middle of each log you can see the beginning. Look closely. In the early morning it is a pond where a fish rises. The rings of the rise that spread out across the surface are like growth rings, each ring each year, each line written, until the last line touches the edge and whispers the same story to the black spruce grown out all around the pond. This is the history of the world. Pass it on.

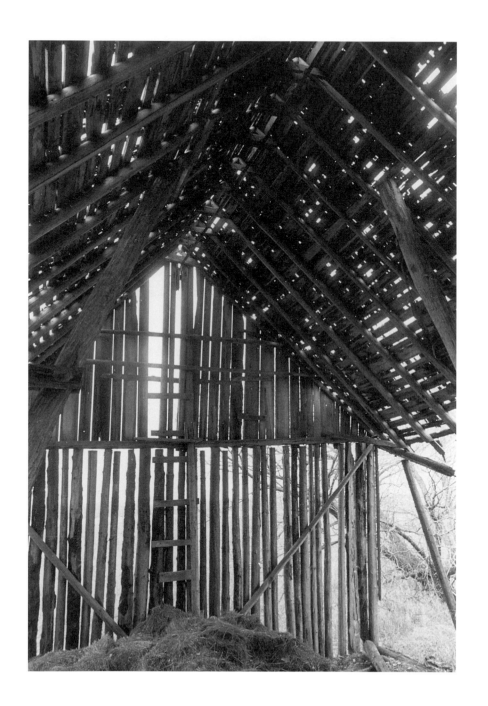

You smile at me that smile toothless as the old hay barn, so many boards missing it is better for drying hay. Only now inside the hay barn there is suddenly so much sun, so much sun the barn is actually rising. Piece by piece it is rising. By now it is almost holy.

I can tell which way the wind is blowing by the way the cows stand always to the wind. If the wind is from the east it will rain and the cows will lie down. If the wind is from the west it will be warm and the cows will move into the trees. So I come to you, your wind from the west, and move into the trees; or your wind from the east, lie down inside.

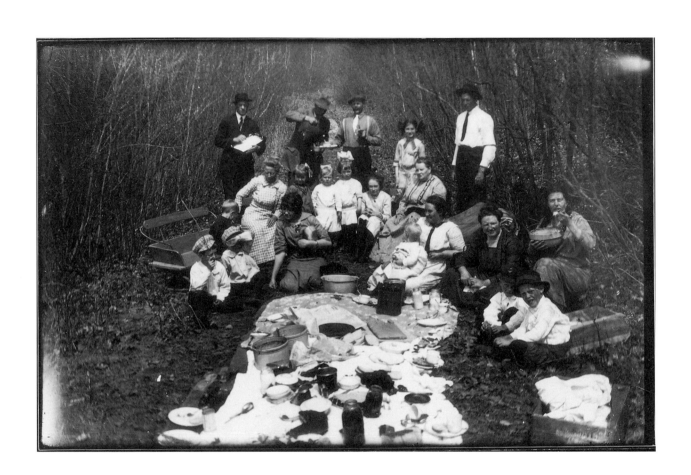

Last summer the dock walked out to the lake but didn't go in. This summer rain, so much rain and so many mushrooms, mushrooms growing everywhere, mushrooms pushing out of the ground like nails nailed in the middle of the trail, or ears on a rock, or even like penises risen from the ground. Of course, the boys were only boys and reported what they saw. They were young enough. And there were so many mosquitos.

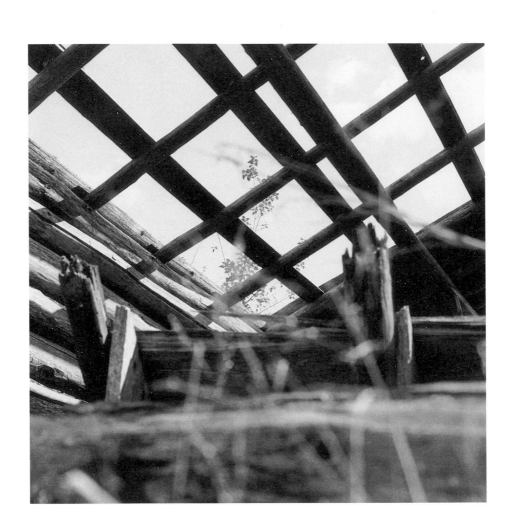

Their wings are thin, gossamer summer evenings in the North.
On the screen door their beaks are even thinner. Once they perched
there and Sulo broke them off. Then their beaks grew longer and
now, after all these years, are almost long enough to even reach you
through the screen door.

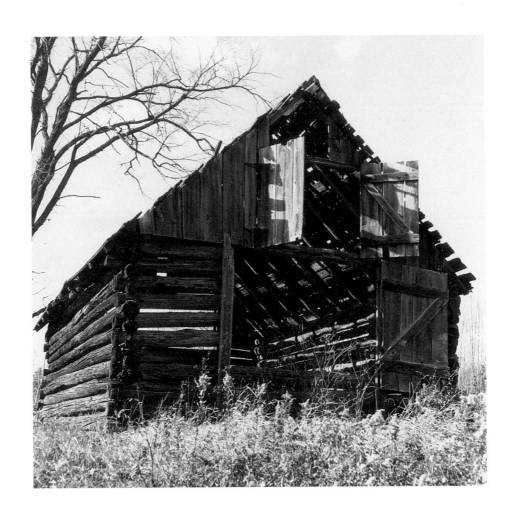

It's hard to say now if the barn is sinking or if the grass is rising up into the sky. You could watch the hill all afternoon and not be sure. Before Sulo cleared the land, he could not see the cemetery and collapsed roofs. He built from what was at hand: rocks for foundations, logs for the walls, boards or shakes for the roofs, and weather. It all blended in in time. The rocks, the logs, the boards, the wind blowing through the gaps between. And it all turned gray.

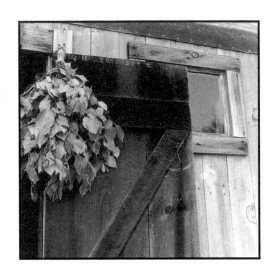

The horizon split like a board where the sun has been nailed down, and in each board there is a definite current, broken only by knots, trout hide under them, the river running straight under the bridge through the middle of town. *Meet me downtown,* the water seems to say. Downtown being not much more than a Co-op store, Mobile station, post office, gift shop, and two taverns, where else could we meet? But the water passes under the bridge and keeps on going, past the houses along Riverside Drive. Behind each house is a sauna. Behind each door, the water we throw onto the rocks, there is fire in the rocks, rises into steam. *Meet me in the other place,* it says.

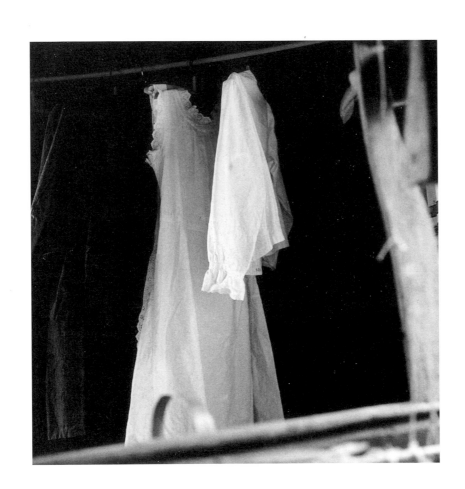

I know Sulo and Martha came across an ocean from an old world to a new world to stand together in a gray light as if it mattered. And it does matter. All morning getting herself ready, she said, worrying about that old man, if he would even be there and then, of course, he was. And now all that is left is an uncut field, the grasses wild and full of wildflowers, an abandoned log house. But look inside. In a closet there will be a long white dress hanging beside a black pin-striped suit, both longing to stand together once again in that light. There will always be so much that could have or would have or should have been said but was not like the spaces between these logs or the spaces between these lines. Even in 1913 these logs were still trees but only dreaming.

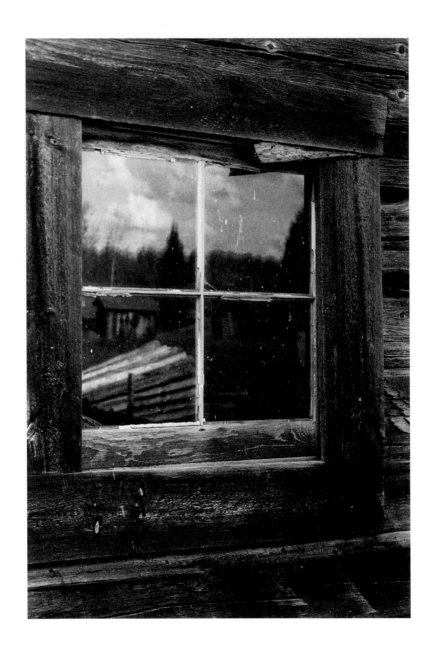

These are the fields Sulo began to mow every fifth of July if it didn't rain and usually it did, but oh how good these fields looked when freshly cut. Now the popple trees are making their way back up to the house. You can already see them in the windows. If the windows are the eyes of the house, the house Sulo himself, the gray logs his bones, then the trees, only a mother would know, are but her children crossing an ocean to be together, a family again.

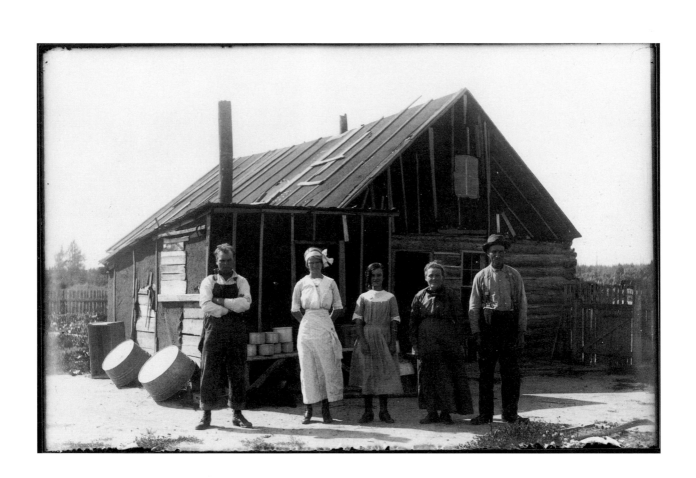

So it is with your family. They are your grandparents. Even
though their hands fall at their sides, you can tell by the way their
feet point out that they are the same. Your eyebrows, mouth too are
straight as the clearcut horizon. It isn't ordinary here. Step through
the slatted gate to the other side. Something is always happening.

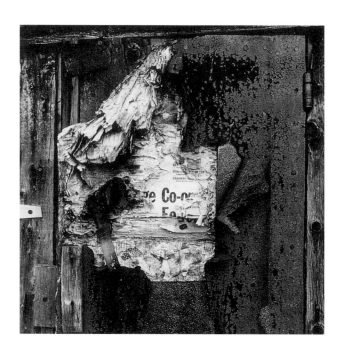

Notes To The Poems

PAGE 11 *Täti* as in Aune Täti is Finnish for *aunt*. Had she survived this narrative, Lillian would have been Lillian Täti.

PAGE 51 *Driving the deer* is an expression used by hunters to refer to the strategy of forcing the deer to move into position to be shot by hunters waiting in ambush, or on a stand. It was often used as a derogatory expression since only gangs of hunters could use hunters as drivers and yet have enough to position others on stands. To make matters worse, drivers often yelled, whistled, and shot into the air thinking the louder they were the more appalling they would be. At least the solitary hunters found this to be true.

PAGE 81 *Kala mojakka* is fish soup. *Kala* is Finnish for fish, but the origin of *mojakka* is unknown. The word does not exist in Finland.

PAGE 87 *Isoäiti* means grandmother.

Biographical Notes

JIM JOHNSON'S poetry is closely tied to his roots in northern Minnesota and reveals his concern for the natural environment and the people and animals of the area. His books, *Finns in Minnesota Midwinter* (1986) and *A Field Guide to Blueberries* (1992), were published by North Star Press of St. Cloud. *Wolves* was published in 1993 by New Rivers Press as a winner in the Minnesota Voices competition. He has done numerous poetry readings and conducted workshops in the Upper Midwest. He currently teaches English in the Duluth School system.

MARLENE WISURI was born and grew up on Minnesota's Mesabi Iron Range. Her photographs have been exhibited regionally and nationally in numerous one-person and group exhibitions. She has an M.F.A. degree from the University of Massachusetts-Dartmouth and has taught photography and photographic history at the college level for eighteen years. She is currently the director of the Carlton County Historical Society in Cloquet, Minnesota, and lives on the North Shore of Lake Superior just out of Duluth.

JESSE C. HENDRICKS (1879-1964) was a pioneer resident of Balsam township in northern Minnesota. He moved there from Iowa in 1909 and cleared a farm out of the wilderness where he lived and raised his family. In about 1912, he became an accomplished amateur photographer using a view camera outfit purchased from Sears Roebuck. For the next several years he documented the life of his family and those of his Finnish immigrant neighbors. The glass plate negatives he exposed were developed and printed at home by his wife, May Gibson Hendricks, and the pictures were often shared at the county fair and other local celebrations. His photos have appeared in a number of television documentaries and publications.